The WALES
COLOURING BOOK

First published 2016

The History Press
The Mill, Brimscombe Port
Stroud, Gloucestershire, GL5 2QG
www.thehistorypress.co.uk

British Library Cataloguing in Publication Data.
A catalogue record for this book is available from the British Library.

ISBN 978 0 7509 6762 4

Cover colouring by Lucy Hester.
Typesetting and origination by The History Press
Printed in Great Britain

THE WALES
COLOURING BOOK

PAST AND PRESENT

Take some time out of your busy life to relax and unwind with this
feel-good colouring book designed for everyone who loves Wales.

Absorb yourself in the simple action of colouring in the scenes from around the country
of Wales, past and present. From iconic cityscapes to picturesque vistas, you are sure to find
some of your favourite locations waiting to be transformed with a splash of colour. Bring
these scenes alive as you de-stress with this inspiring and calming colouring book.

There are no rules – choose any page and any choice of colouring pens or pencils
you like to create your own unique, colourful and creative illustrations.

Conwy Castle ▸

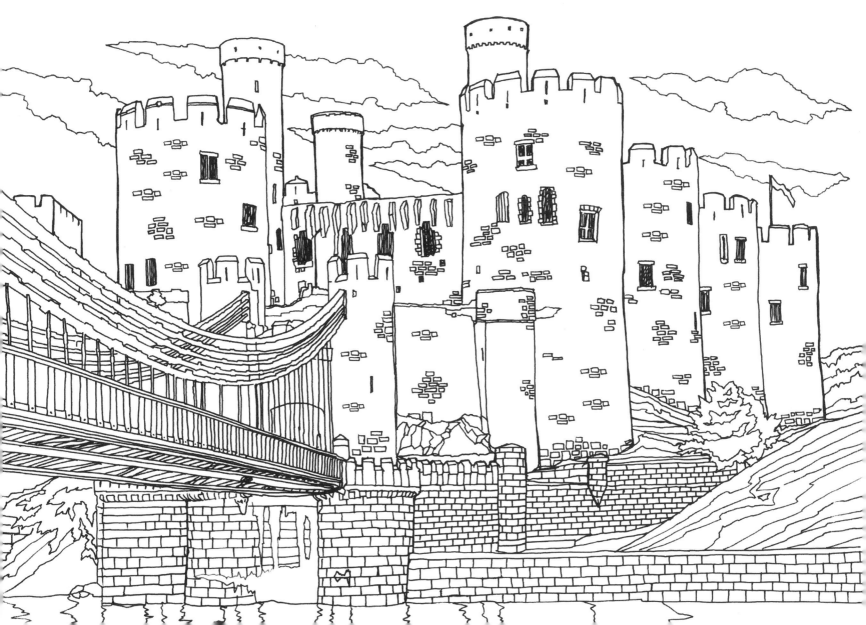

Rhyl Promenade in 1932 ▸

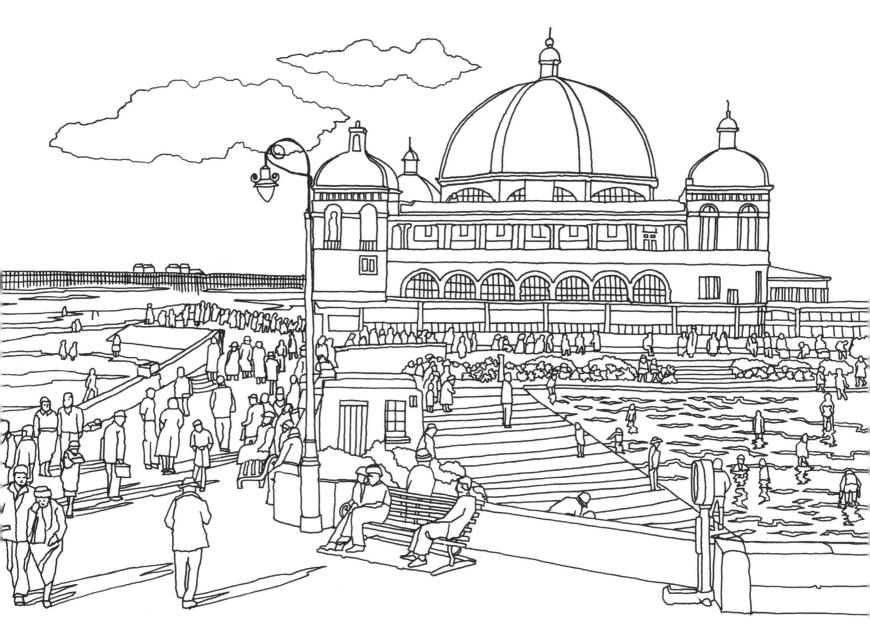

Two ladies in traditional Welsh dress, *c.* 1875 ▶

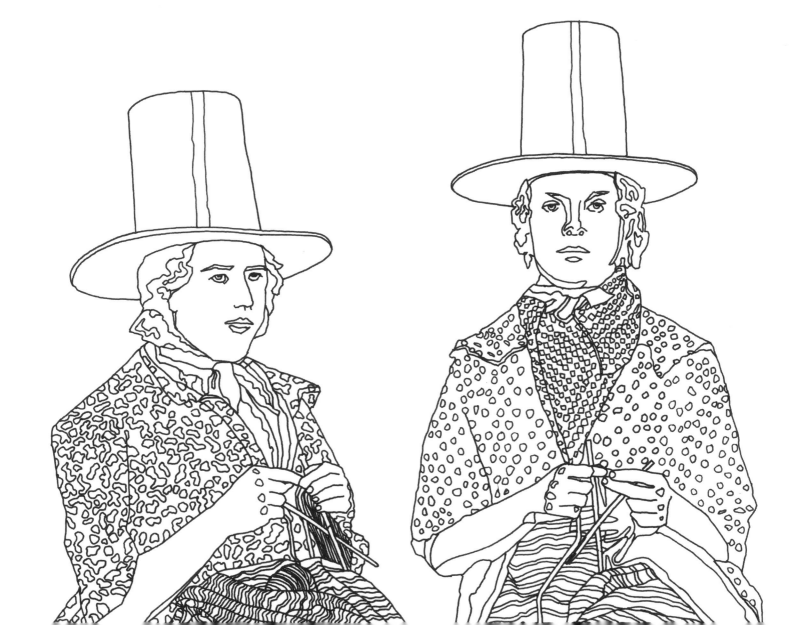

Caernarfon Castle ▶

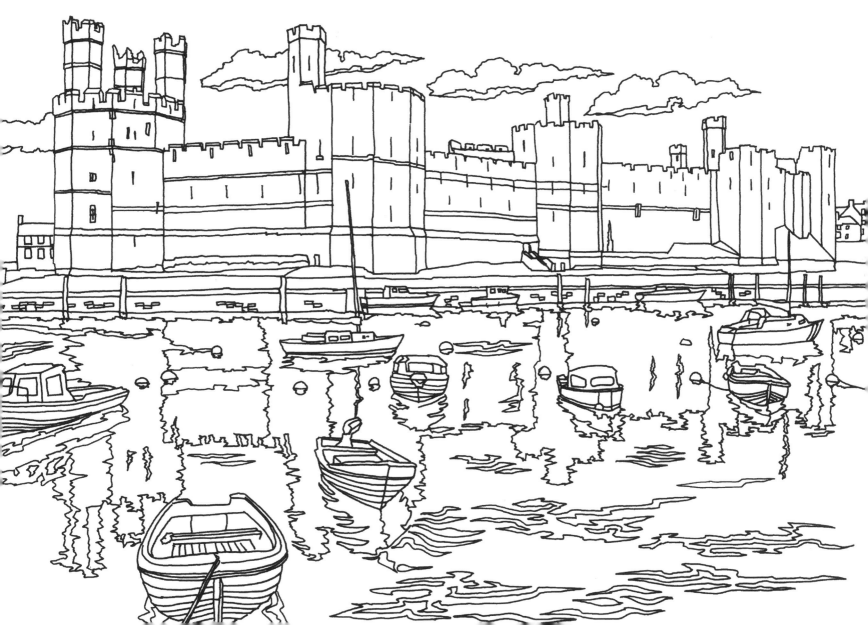

Saturday shoppers in Abergavenny ▶

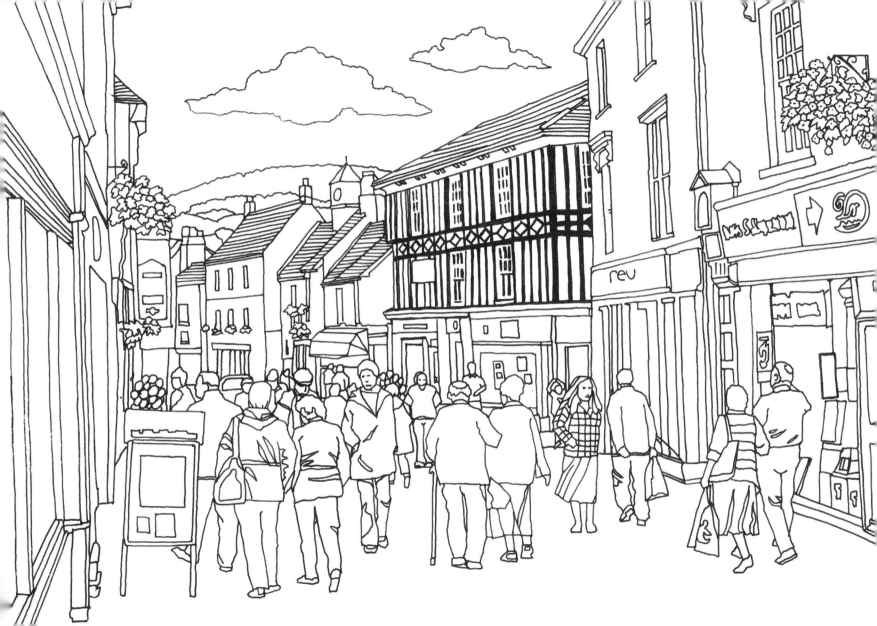

Beaumaris Castle ▶

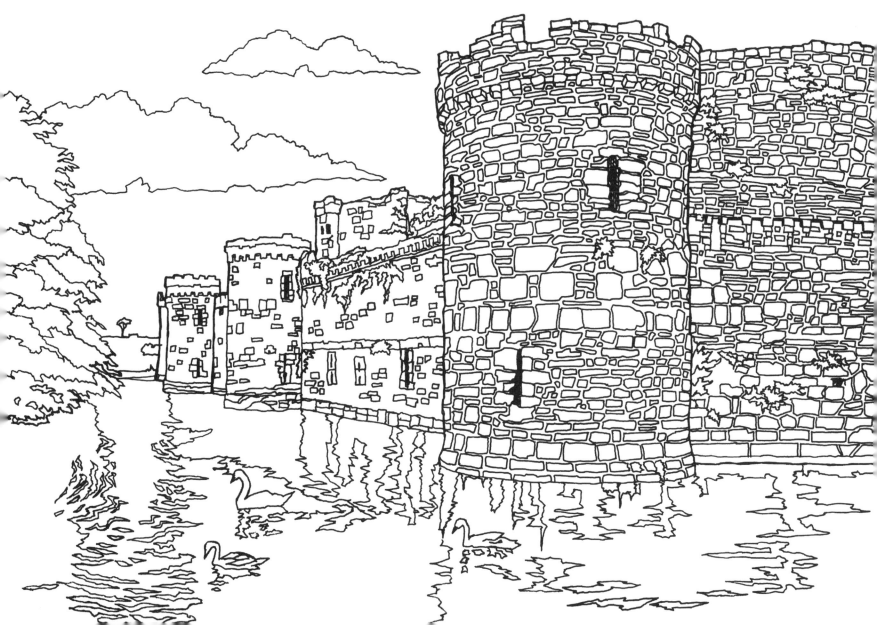

Steel Wave, Newport. Peter Fink's giant metal
construction, built in recognition of Newport's
debt to its steel industry, has become an
integral feature of the Newport landscape ▸

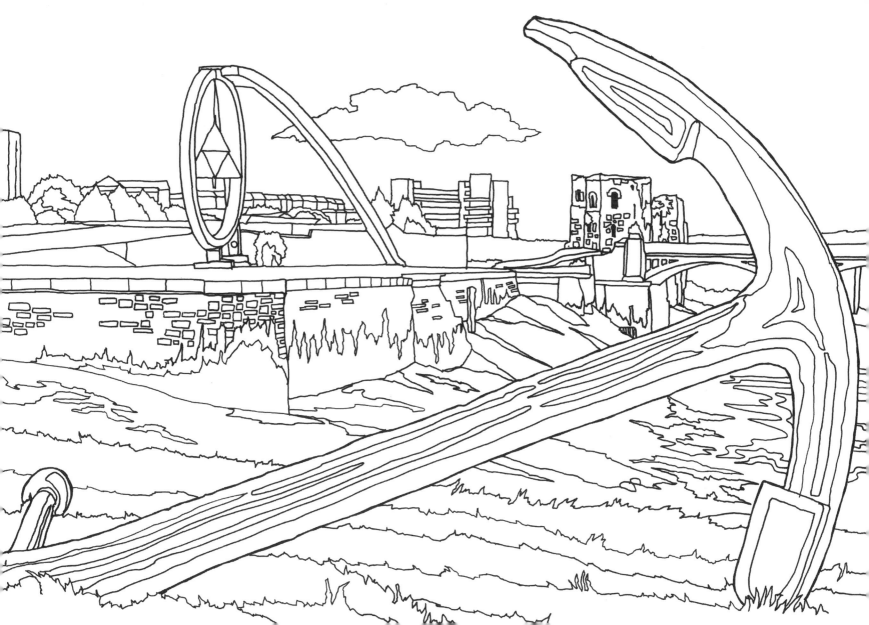

Aberystwyth Castle ▶

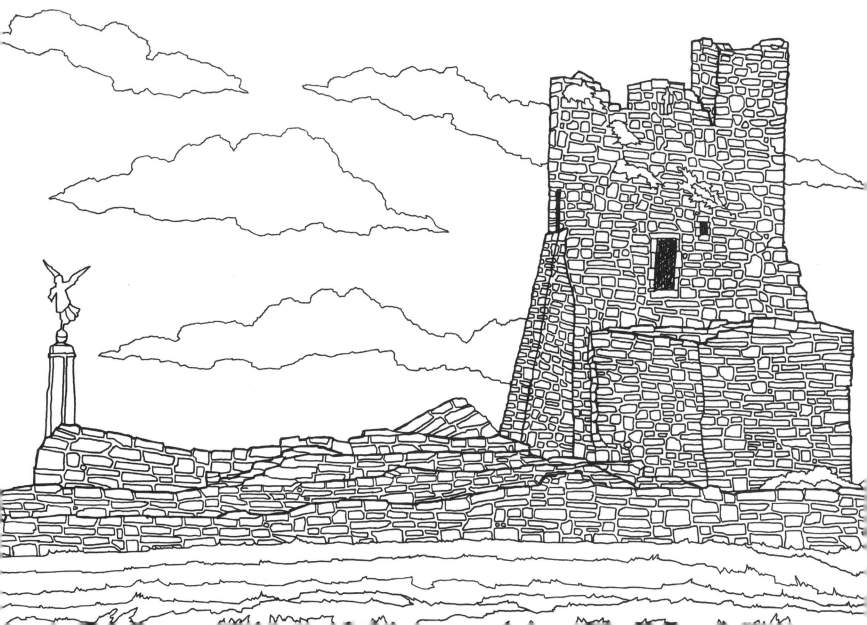

Aberystwyth Pier, 1899 ▸

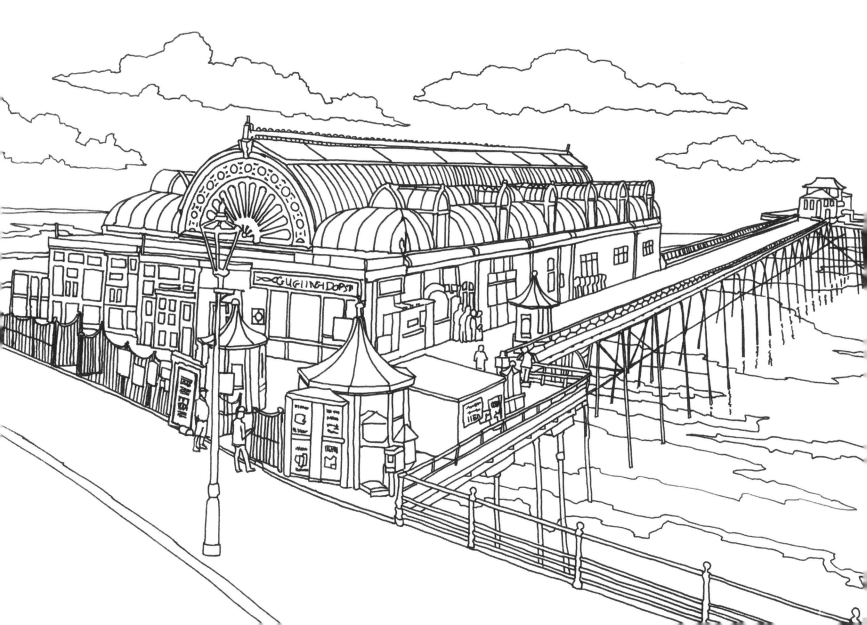

St Giles' Church, Wrexham ▸

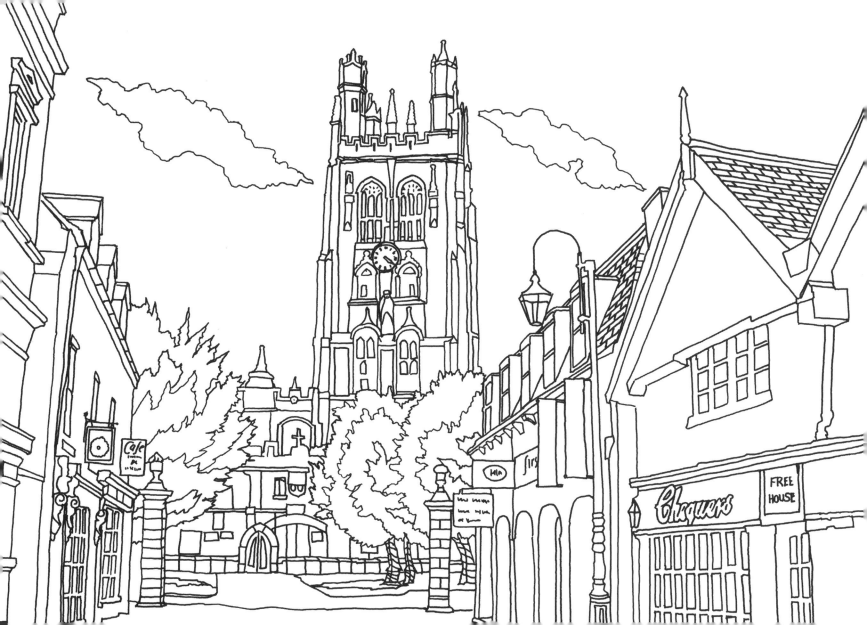

Brecon Beacons National Park ▸

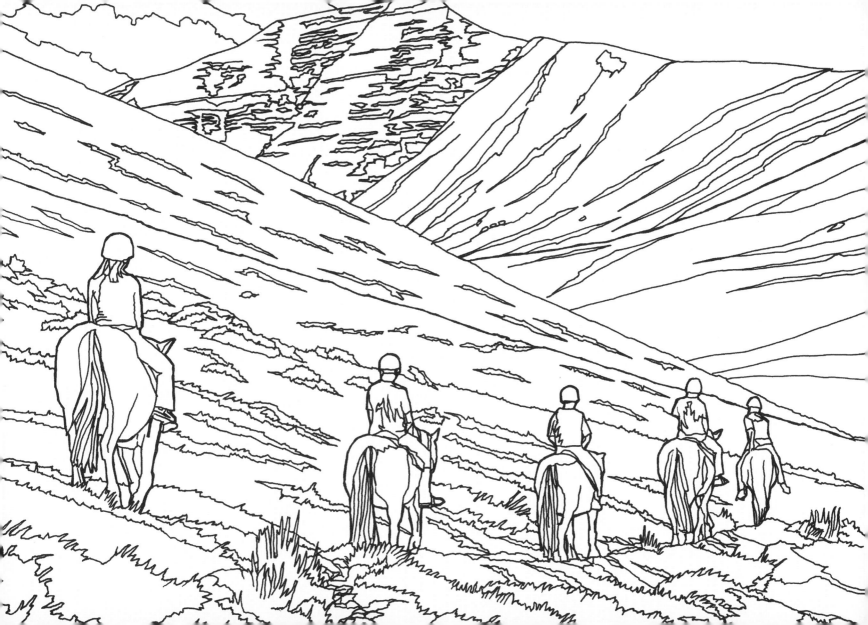

Gun Tower Museum, Pembroke Dock ▸

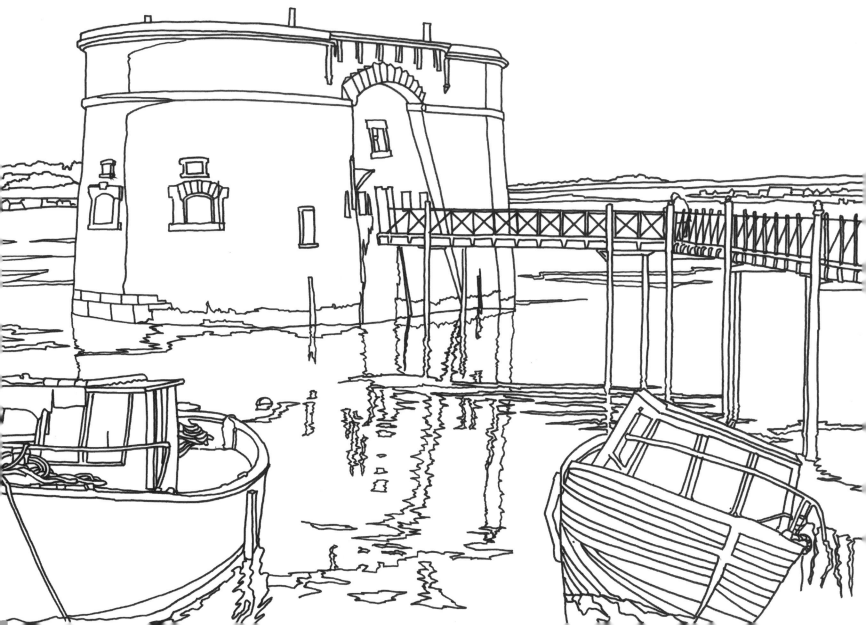

The National Museum of Wales, Cardiff ▸

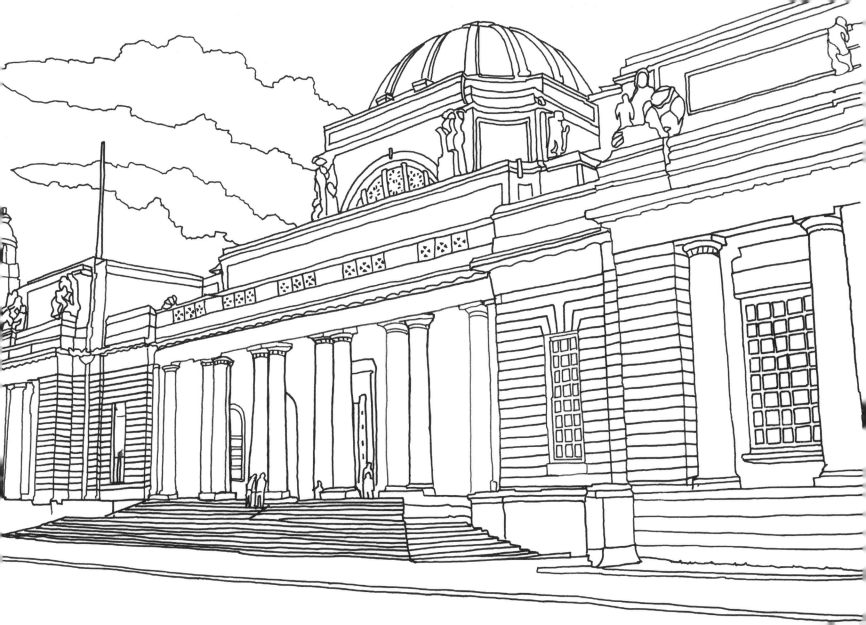

Caerphilly Castle ▶

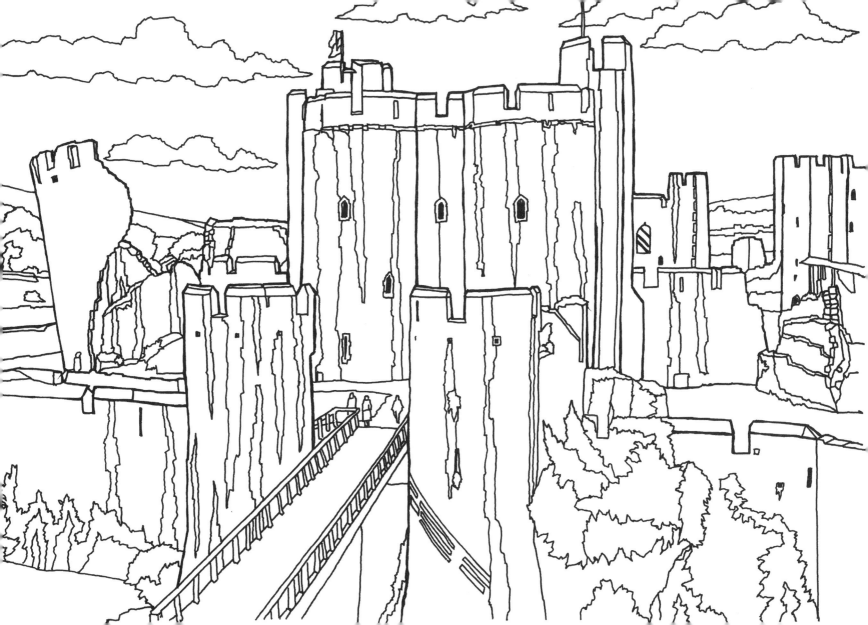

The Cambrian Mountains ▸

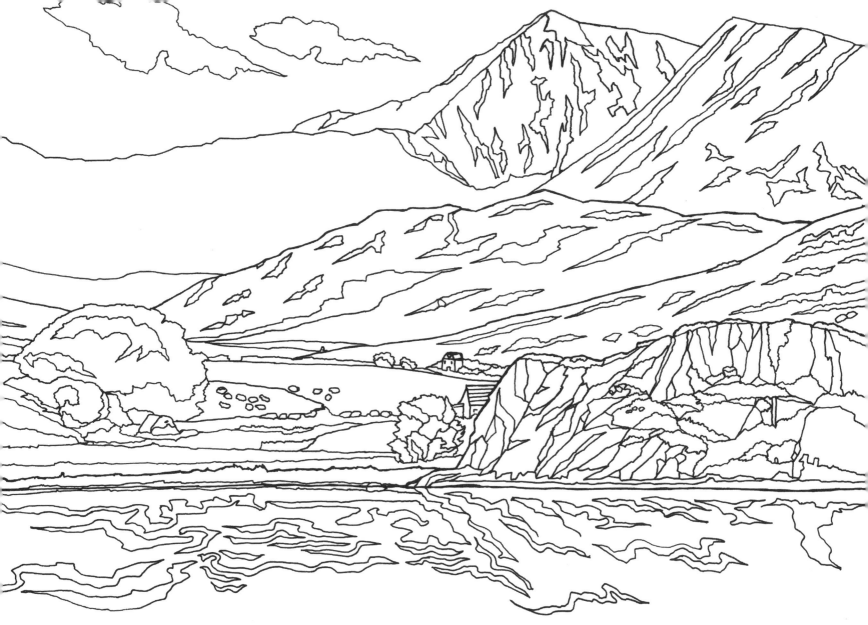

The Millennium Centre is Wales' national
home for the performing arts in Cardiff Bay ▸

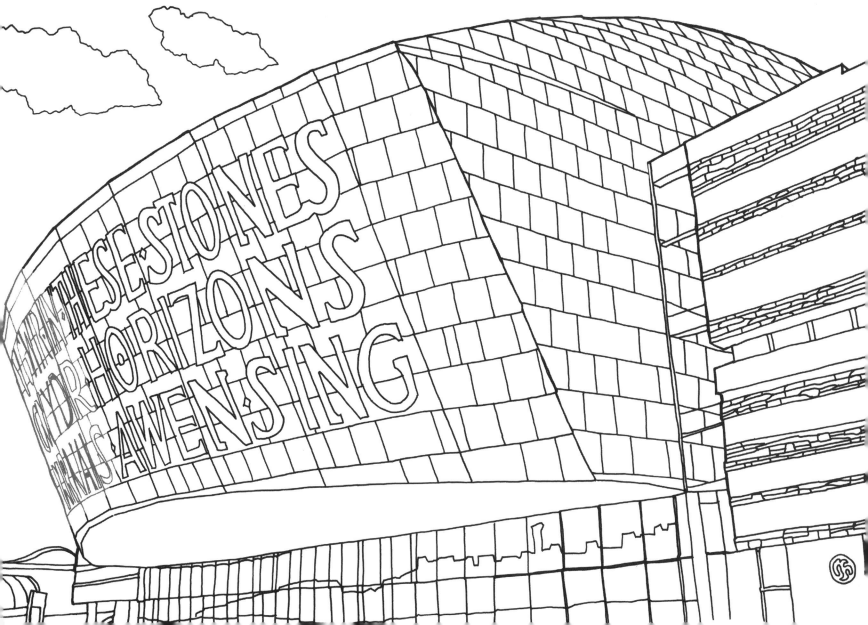

The Welsh red dragon is the national
icon and symbol of Wales and appears
on the national flag of Wales ▶

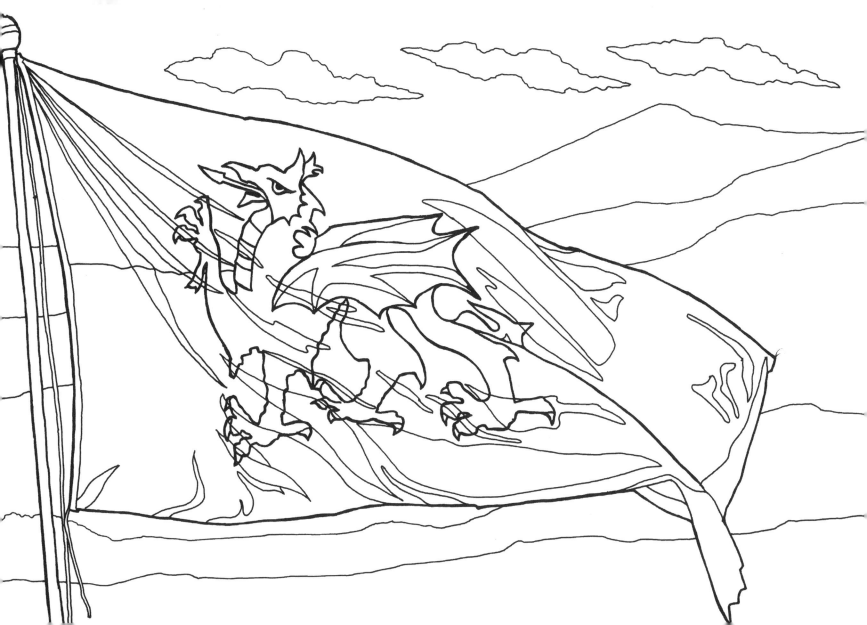

Snowdon Mountain Railway ▸

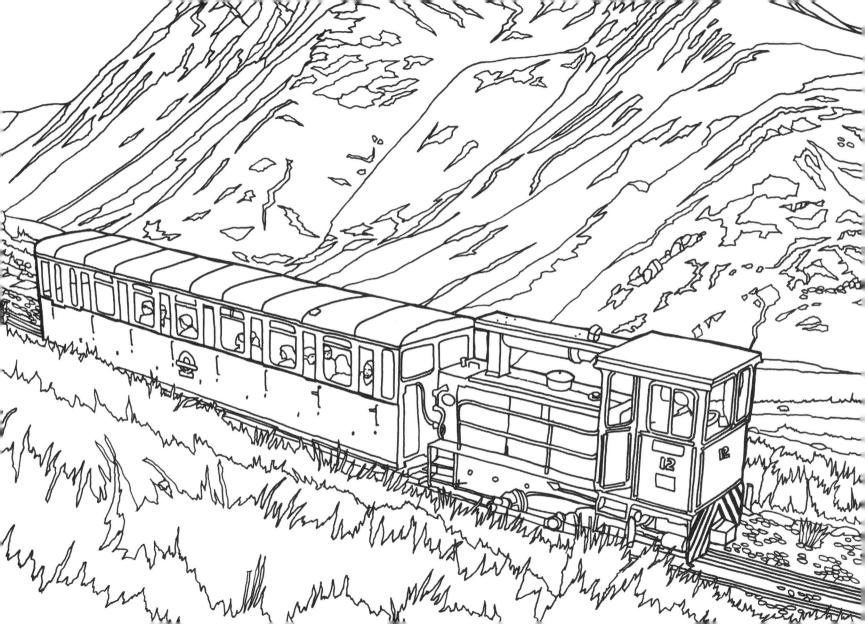

Cardiff Castle ▸

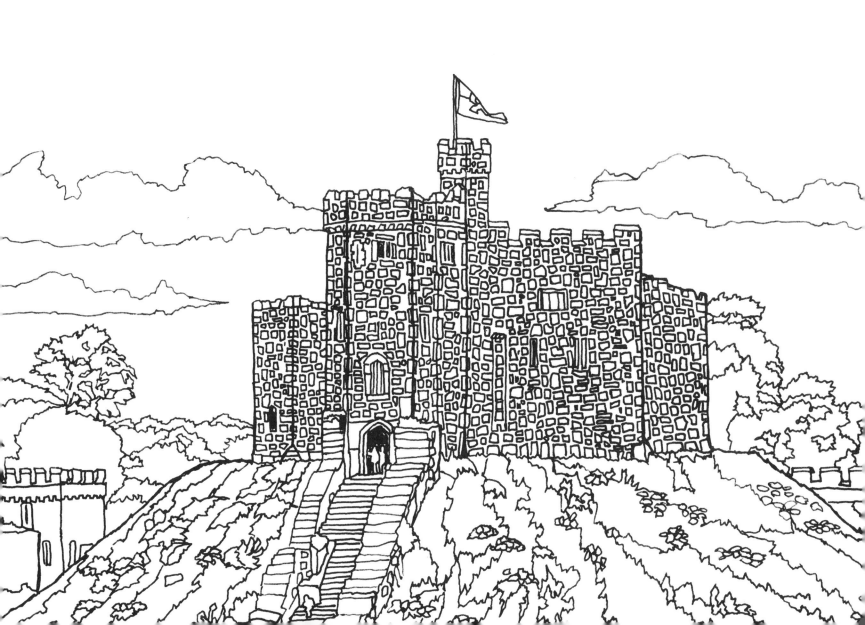

Cardigan Bay ▶

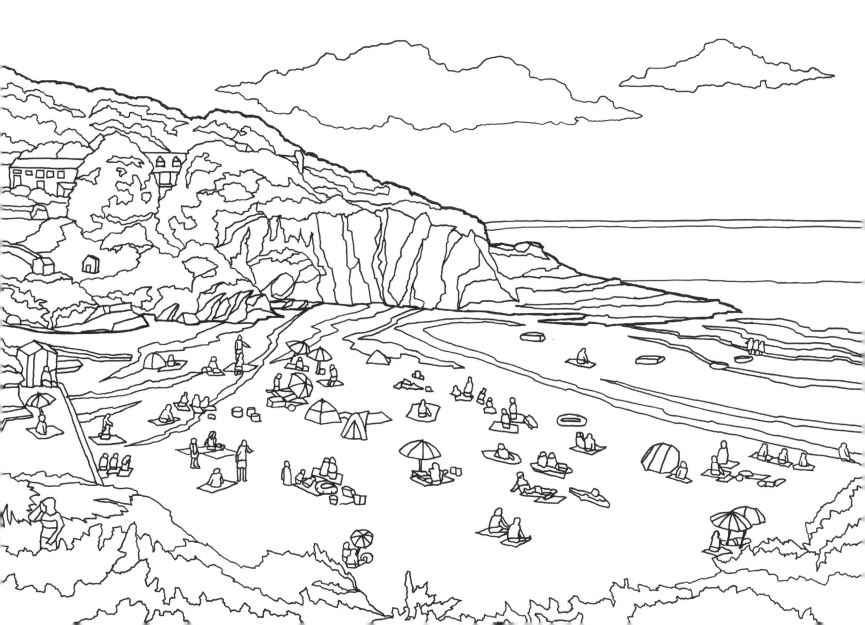

The Principality Stadium is the national
stadium of Wales, located in Cardiff ▸

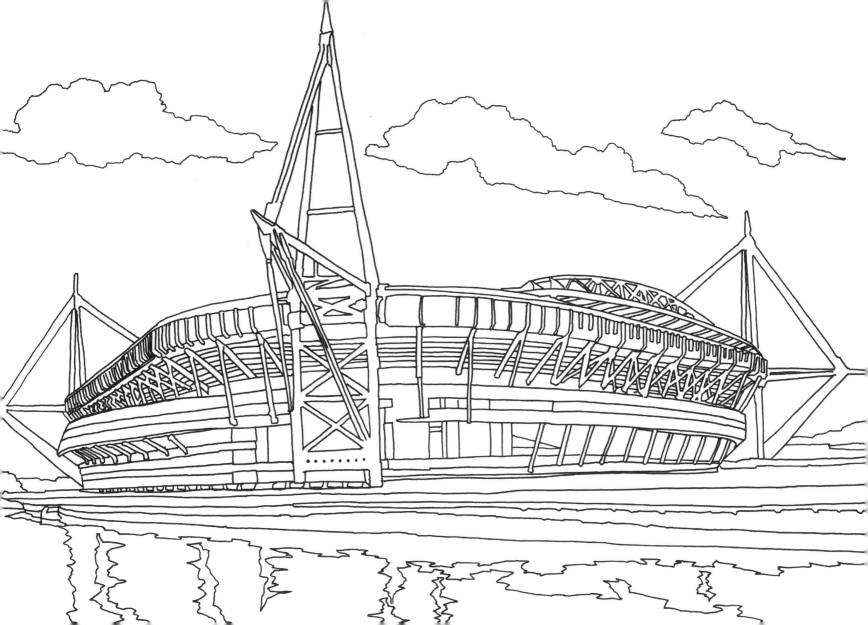

Castell Coch ▶

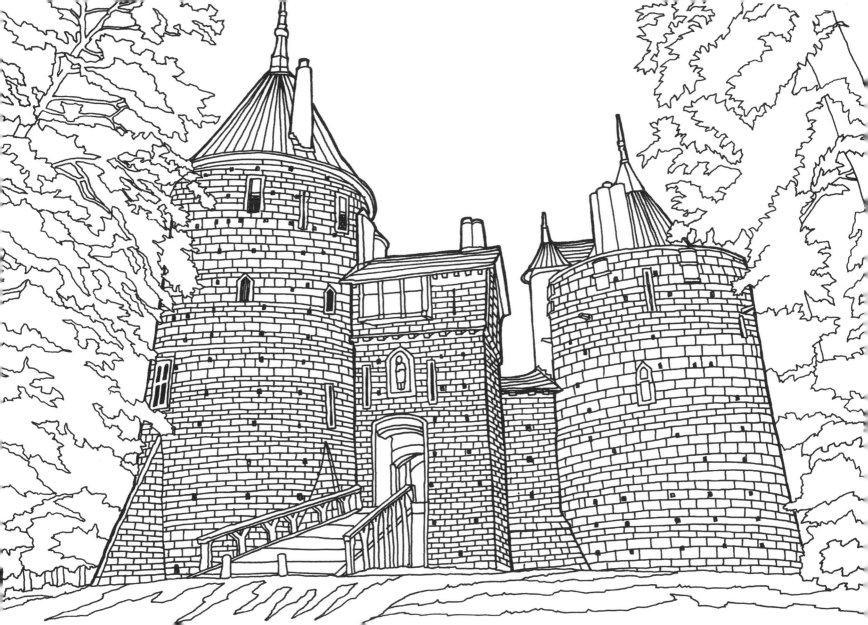

A tram on the Great Orme Tramway
overlooking Llandudno Bay ▸

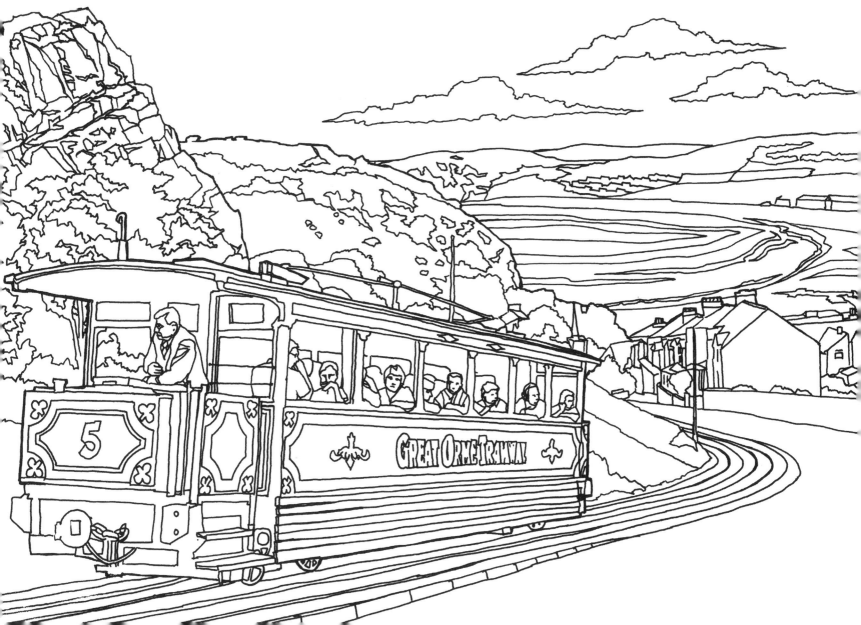

Chepstow Castle ▶

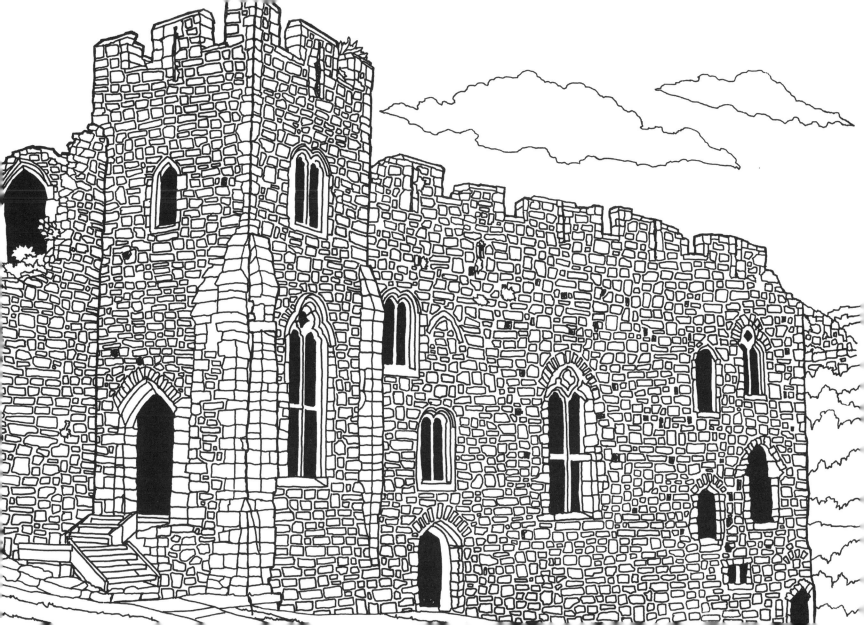

Beach huts at Barry Island ▶

Brecon Cathedral ▶

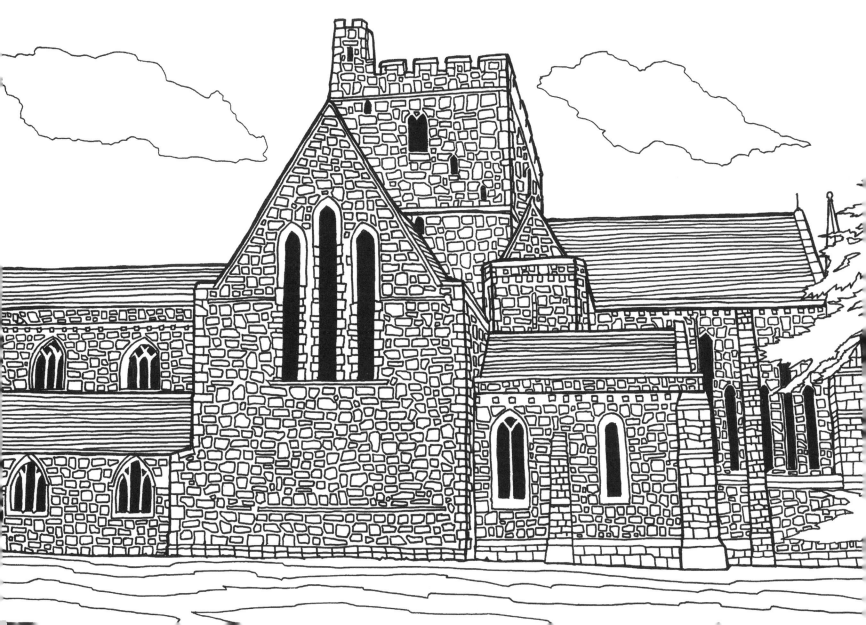

Caerleon Roman Amphitheatre ▸

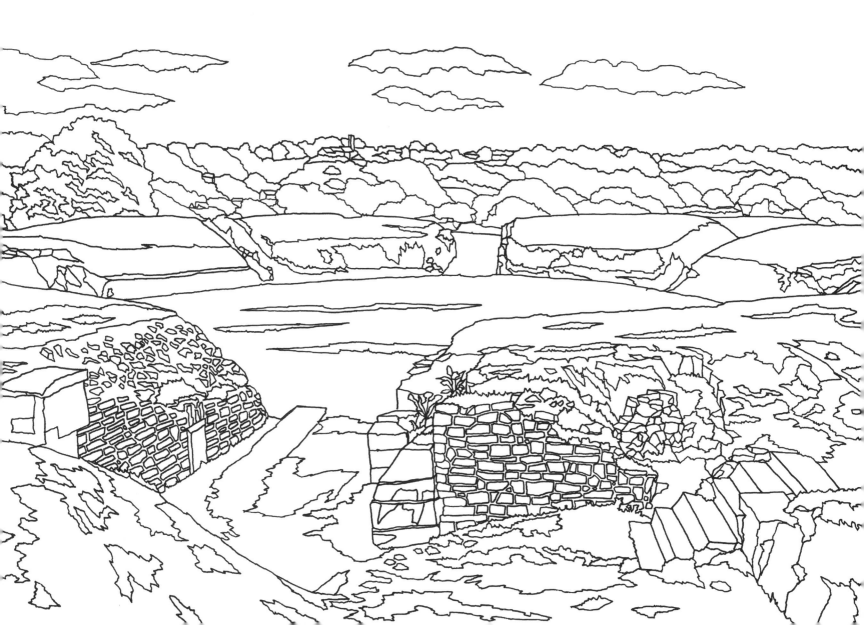

The Ffestiniog Railway, Porthmadog station ▶

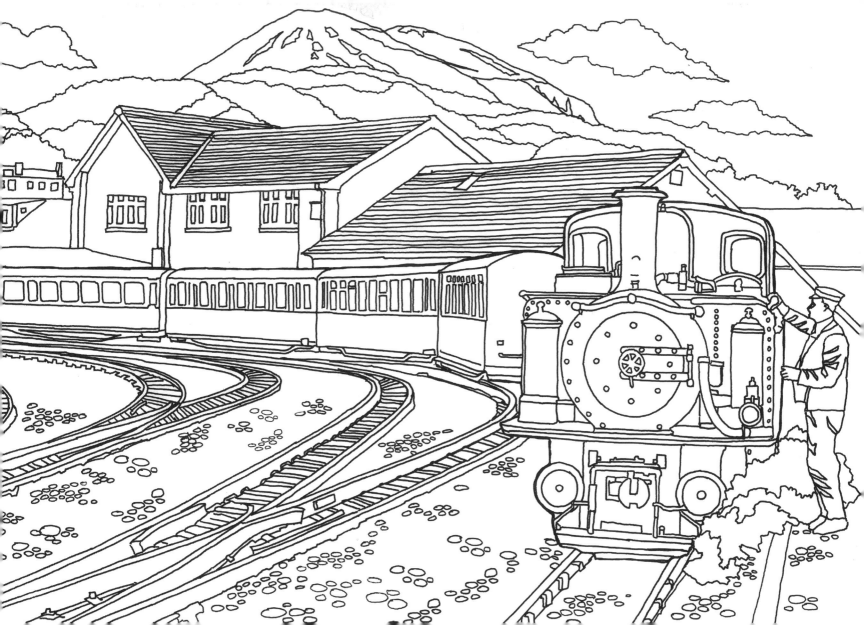

St Davids Cathedral ▸

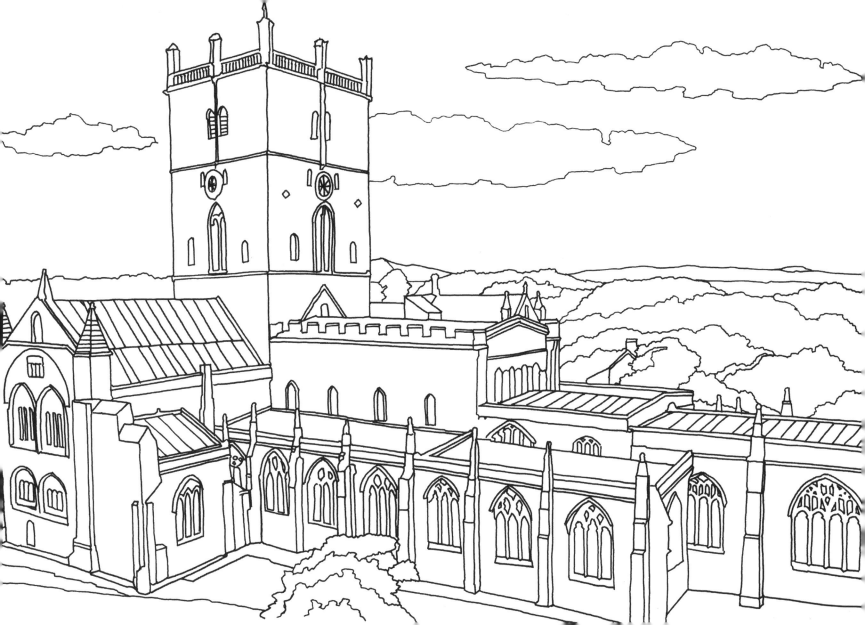

Funfair at Barry Island, 1978 ▸

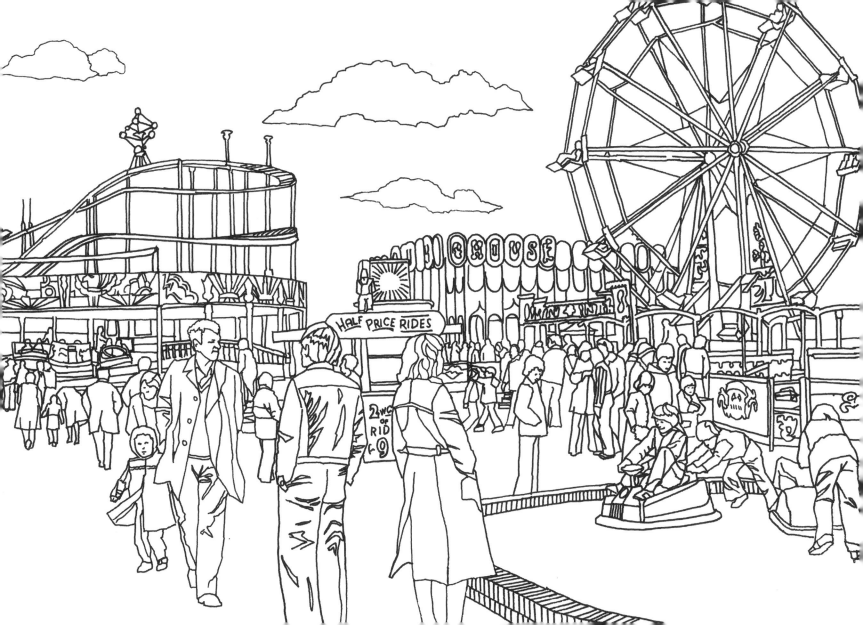

Harlech Castle ▶

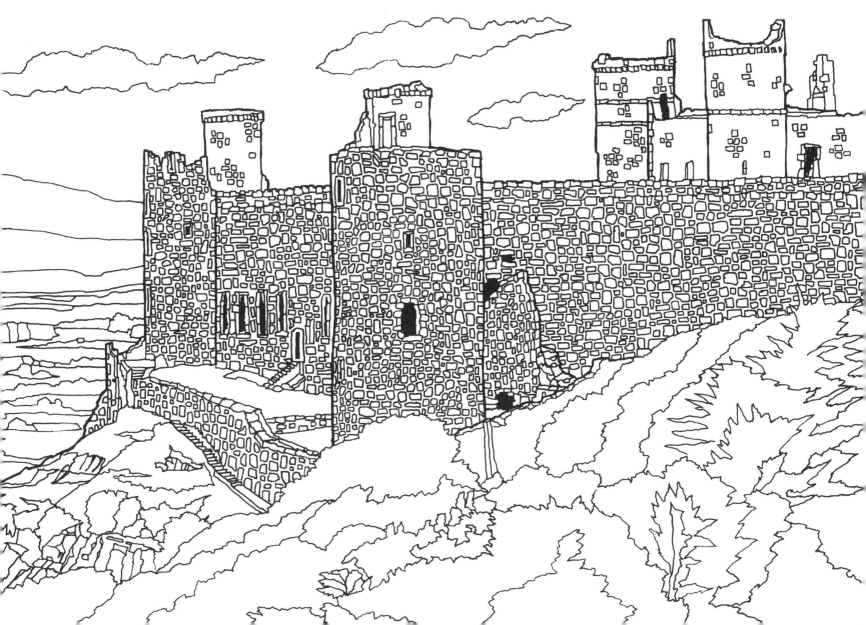

Hay-on-Wye, home to the annual book festival ▶

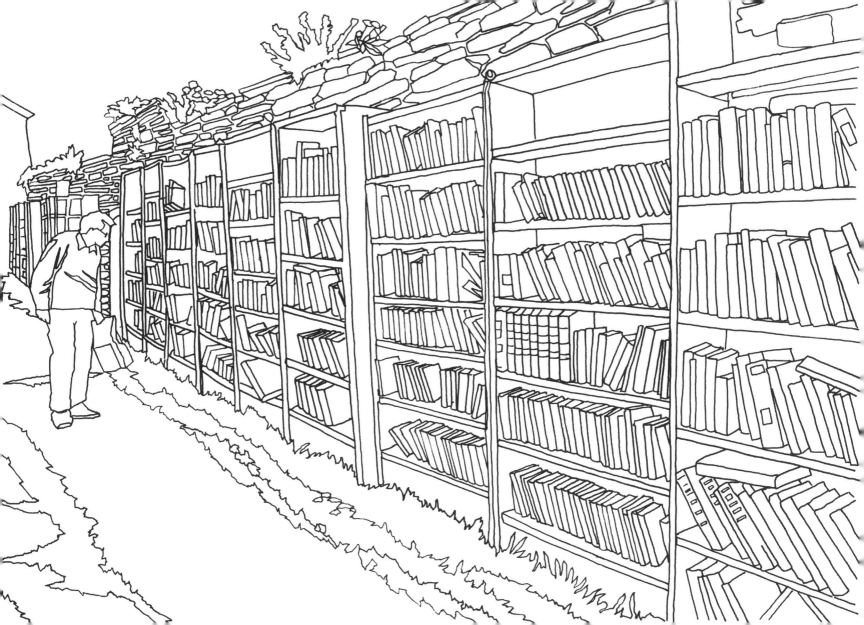

Castle Square, Swansea ▶

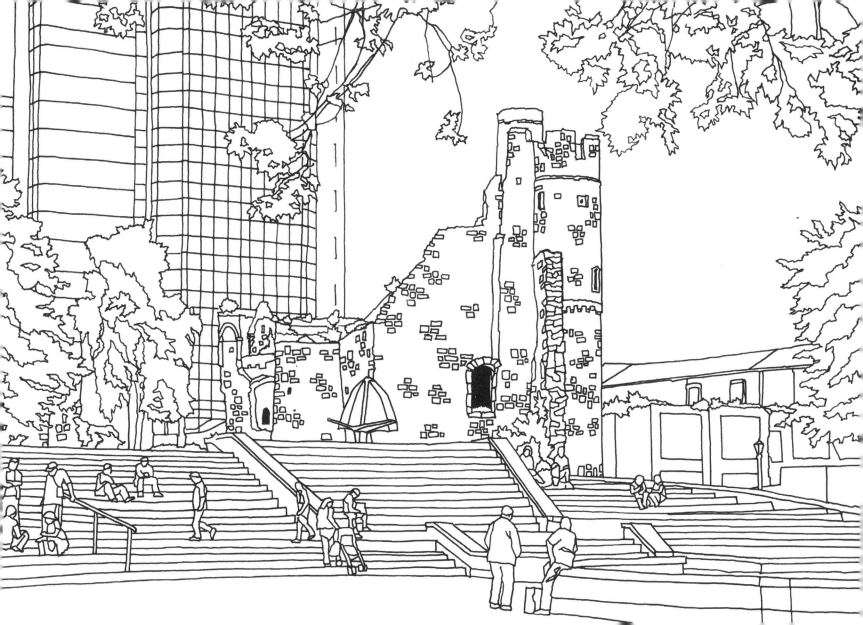

Llandaff Cathedral ▶

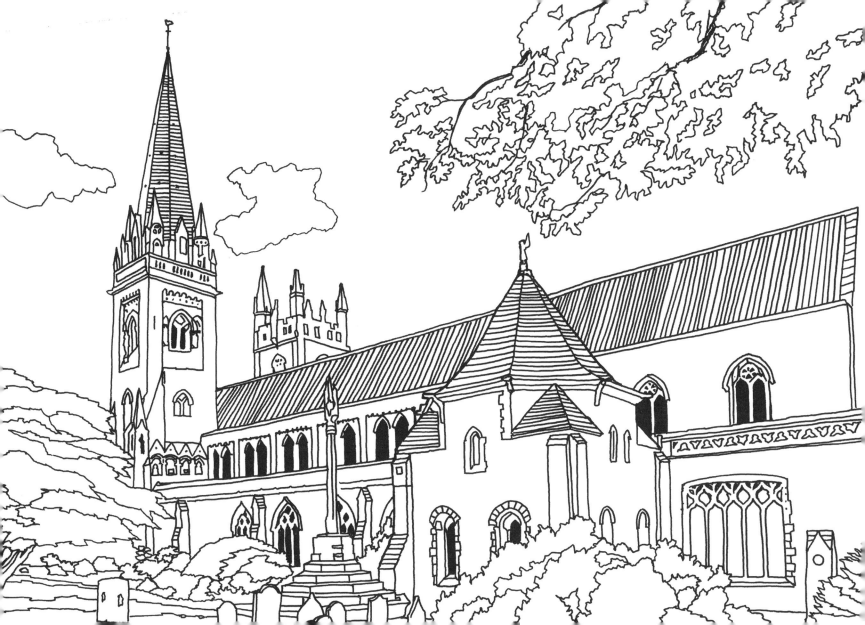

Menai Suspension Bridge ▸

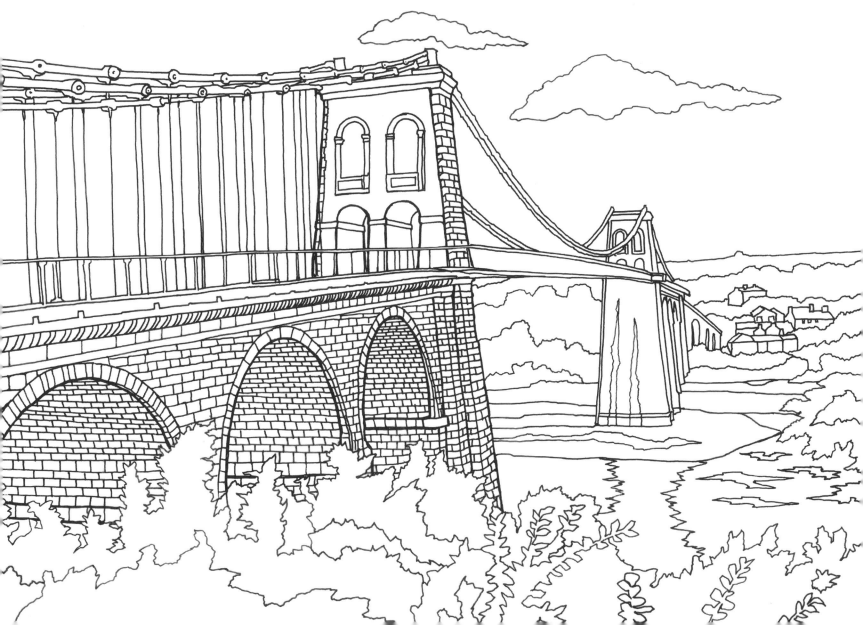

Portmeirion, Gwynedd, was designed
and built by Sir Clough Williams-Ellis
in the style of an Italian village ▶

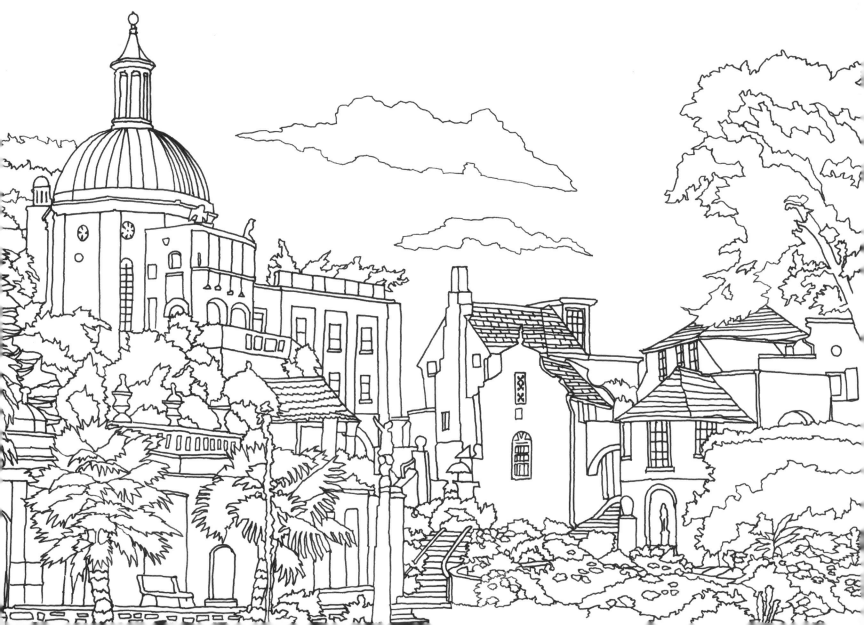

Located in Snowdonia National Park, Snowdon
is the highest mountain in Wales, at an
elevation of 1,085 metres above sea level ▶

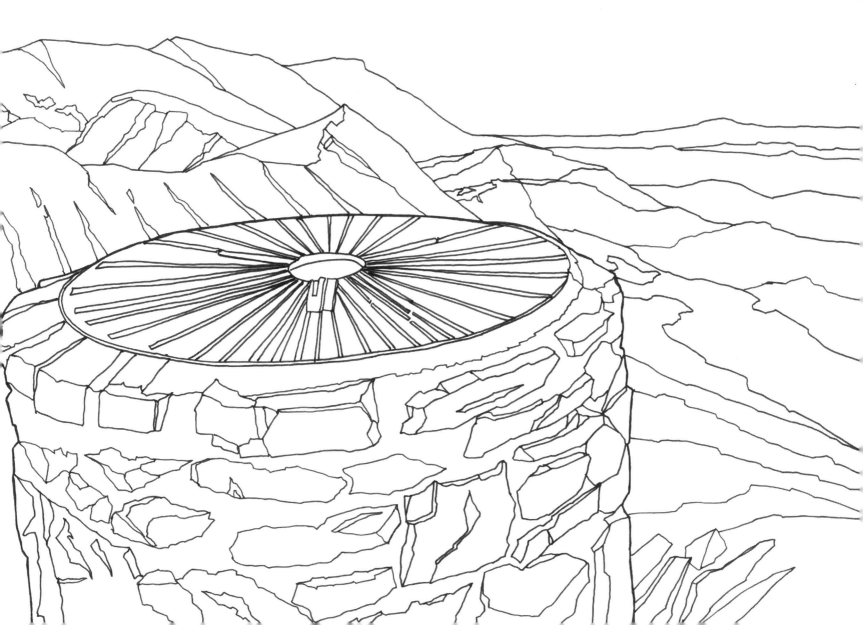

Raglan Castle ▶

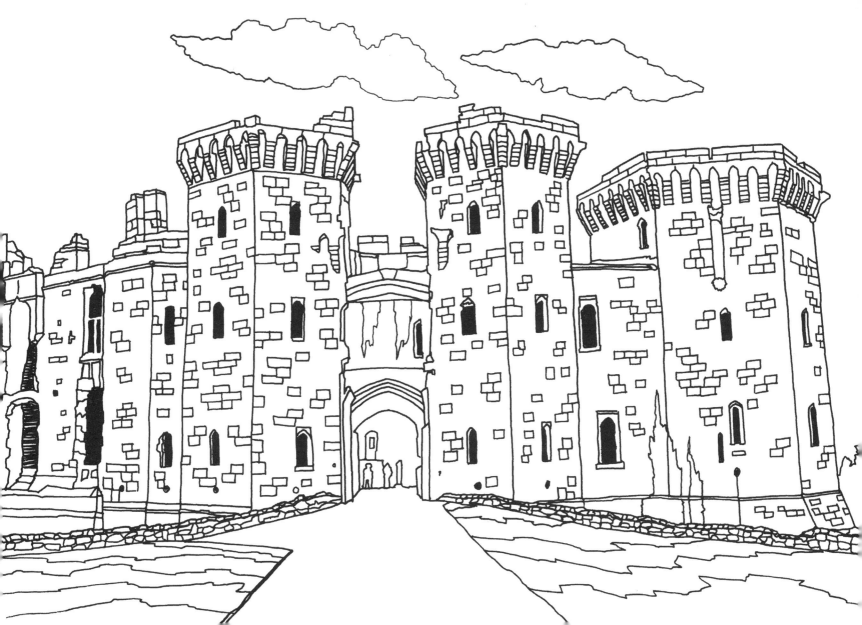

The Owain Glyndŵr Centre in Machynlleth ▶

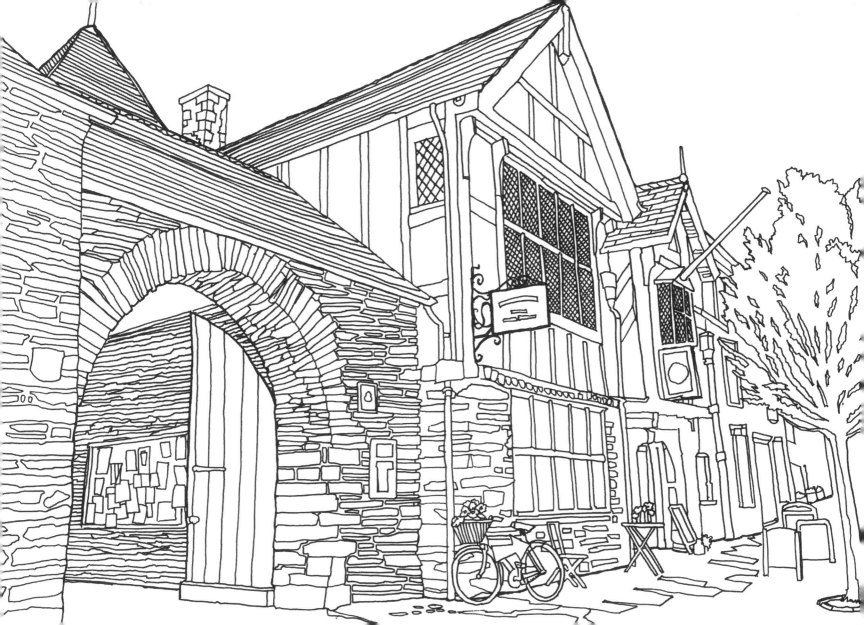

The Royal Arcade, Cardiff ▶

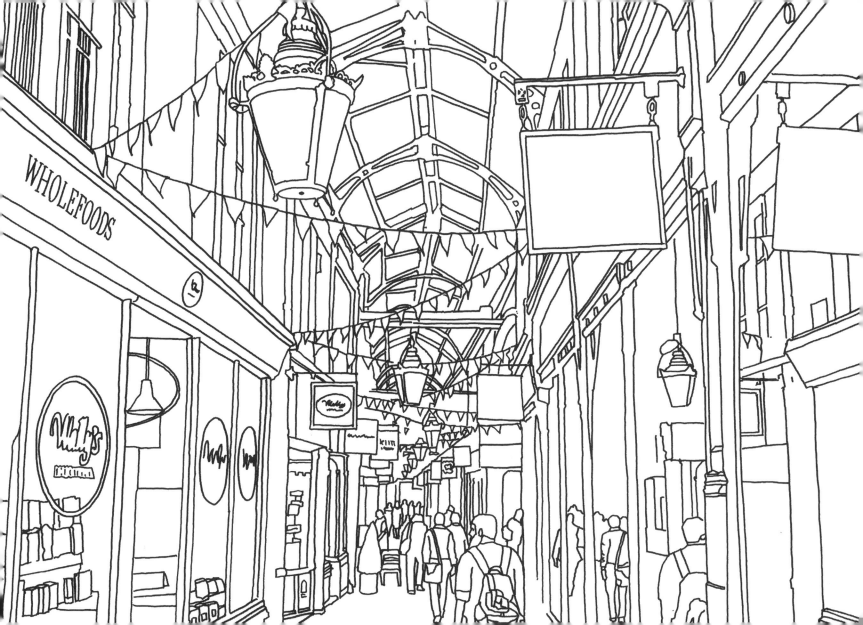

Pontcysyllte Aqueduct, Wrexham ▶

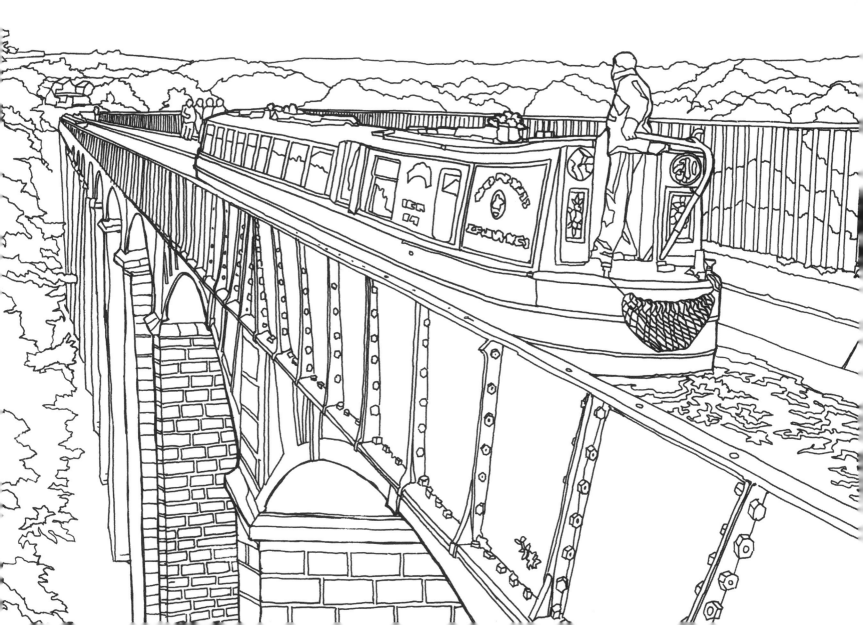

Tenby, Pembrokeshire ▸

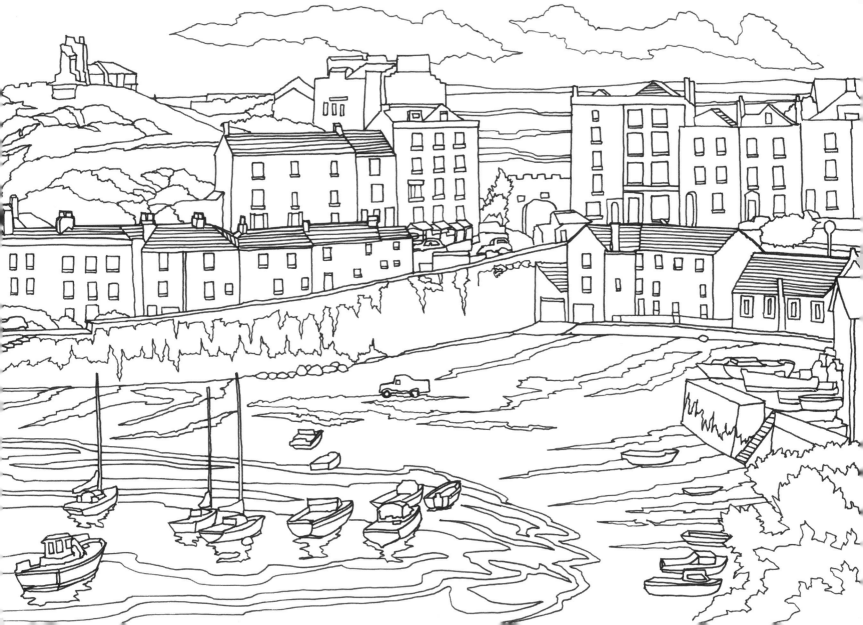

The Pierhead Building in Cardiff Bay, with
the Wales Millennium Centre behind ▸

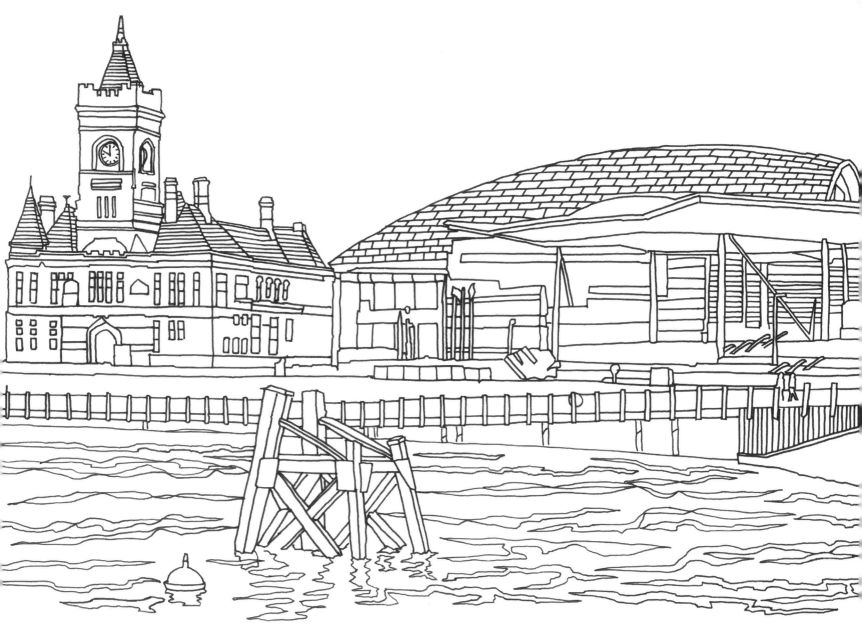

Rhondda Heritage Park – a living
testament to the mining communities
of the Rhondda Valleys ▸

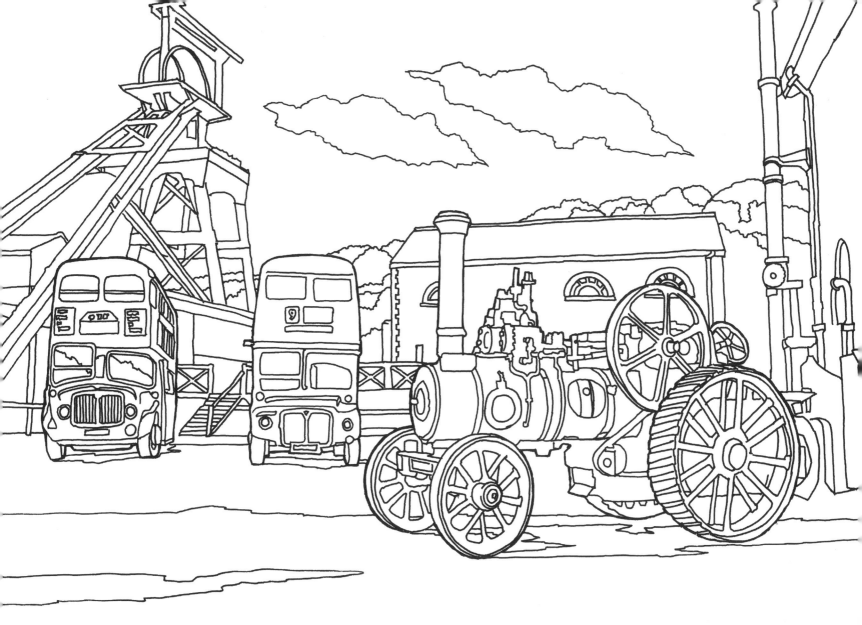

Tintern Abbey ▸

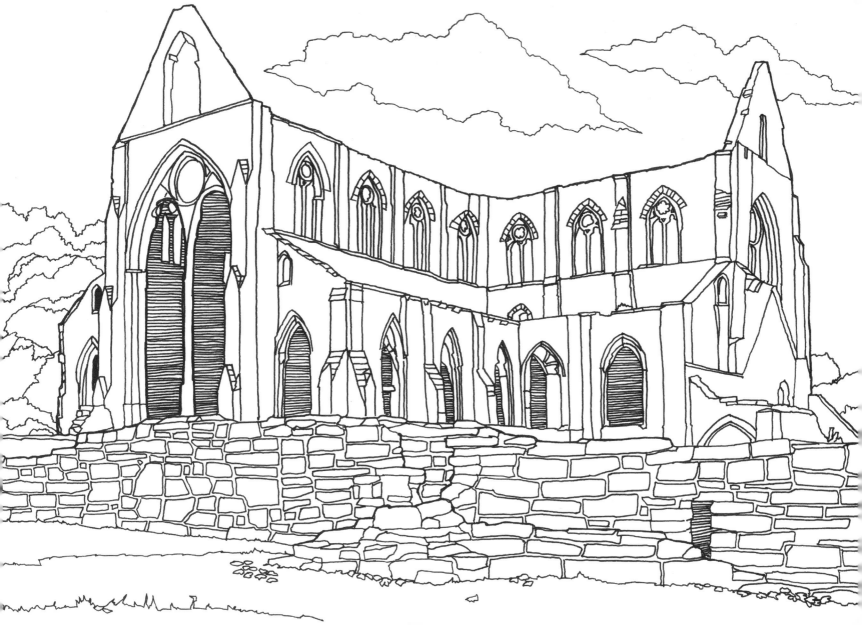

Also from The History Press

Find this colouring book and more at

www.thehistorypress.co.uk